INDIAN TEXTILE PRINTS

AGILE RABBIT EDITIONS DISTRIBUTED BY THE PEPIN PRESS

INDIAN TEXTILE PRINTS

Other books with free CD-ROM by Agile Rabbit Editions:

ISBN 90 5768 004 1 Batik Patterns
ISBN 90 5768 006 8 Chinese Patterns
ISBN 90 5768 001 7 1000 Decorated Initials
ISBN 90 5768 005 x Floral Patterns
ISBN 90 5768 003 3 Graphic Frames
ISBN 90 5768 007 6 Images of the Human Body
ISBN 90 5768 008 4 Sports Pictures
ISBN 90 5768 002 5 Transport Pictures
ISBN 90 5768 010 6 Signs and Symbols
ISBN 90 5768 011 4 Ancient Mexican Design
ISBN 90 5768 012 2 Geometric Patterns

ISBN 90 5768 009 2

A catalogue record for this book is available from the publishers
and from the Dutch Royal Library, The Hague

This book is edited, designed and produced by Agile Rabbit Editions
Design: Joost Hölscher
Copy-editing introduction: Andrew May
Translations: Sebastian Viebahn (German); LocTeam (Spanish);
Anne Loescher (French); Luciano Borelli (Italian);
Mitaka (Chinese and Japanese)

Printed in Singapore

INDIAN TEXTILE PRINTS

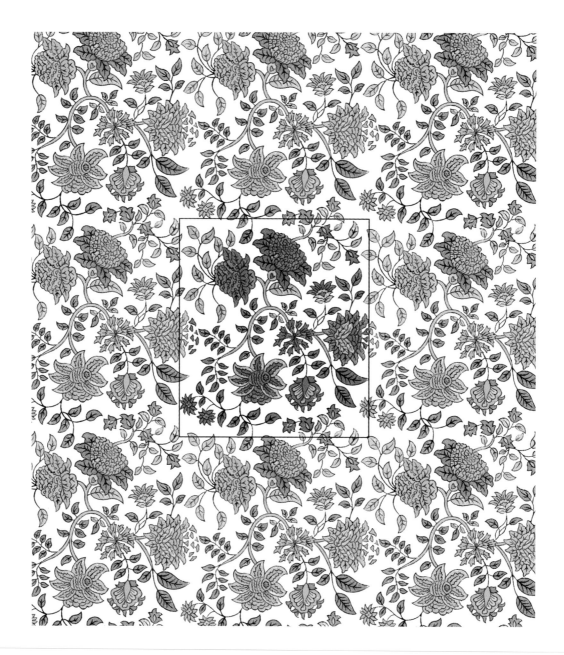

Example (repetition of the design on page 95)

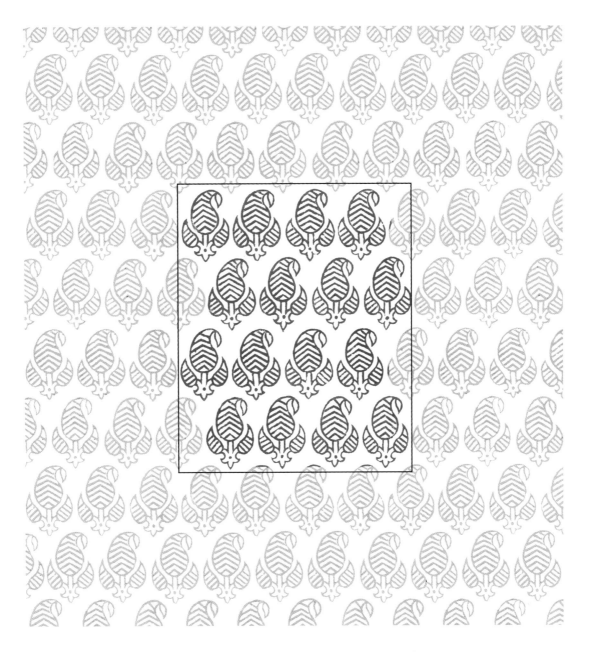

Example (repetition of the design on page 61)

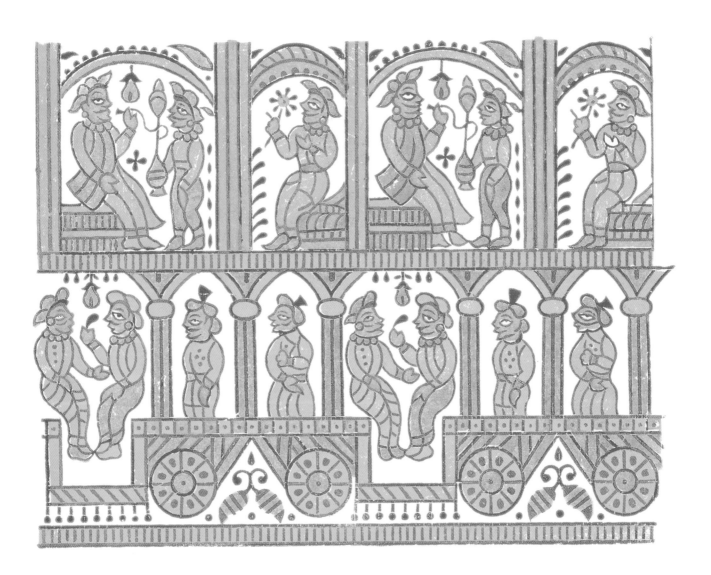

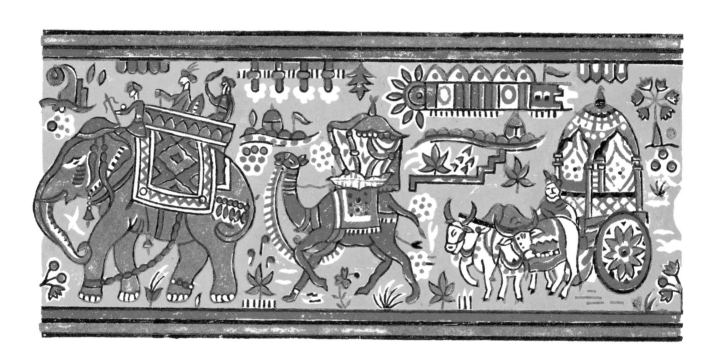

13

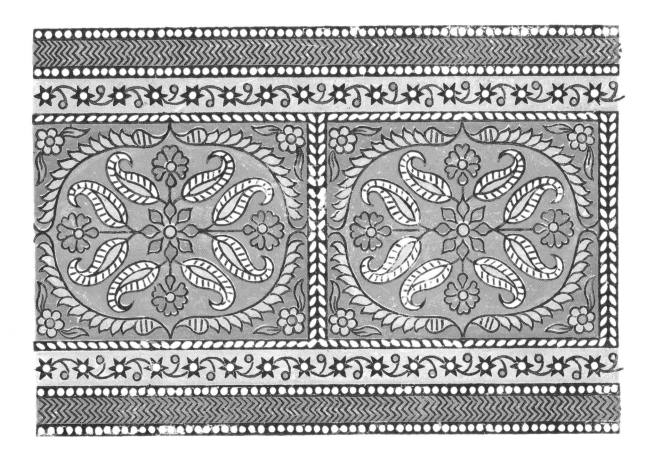

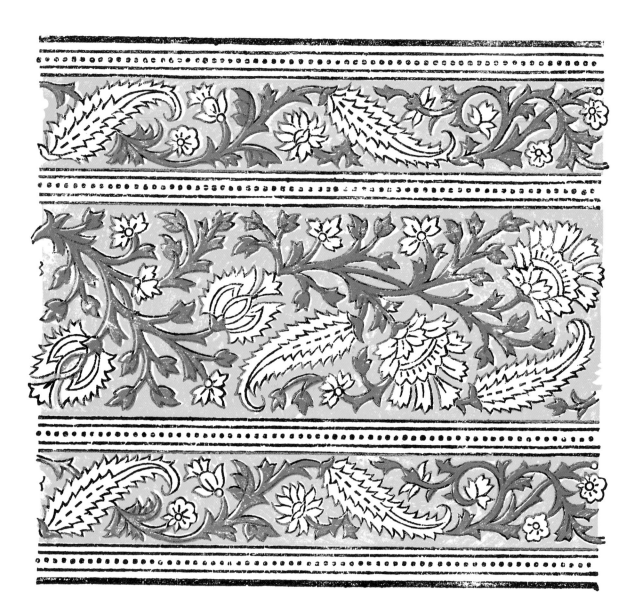

28

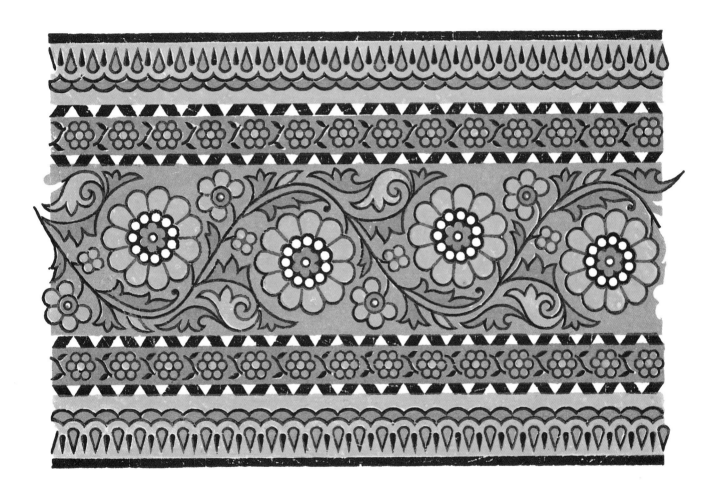

29

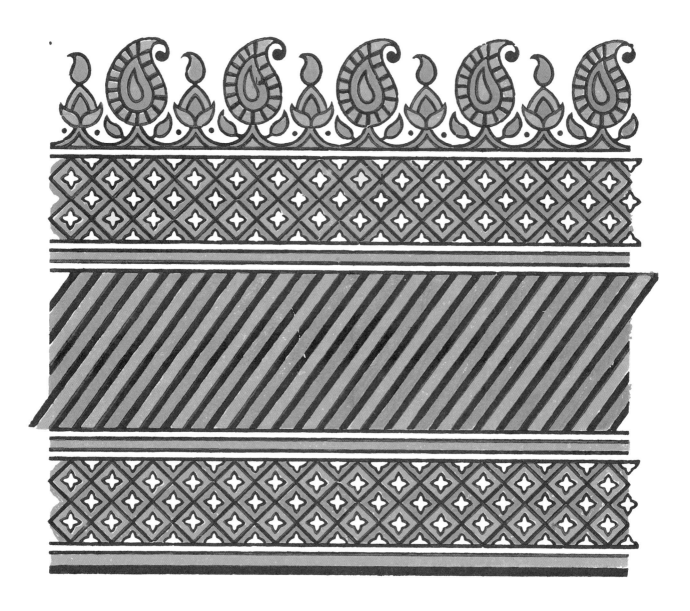

31

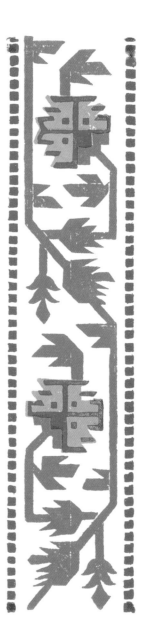

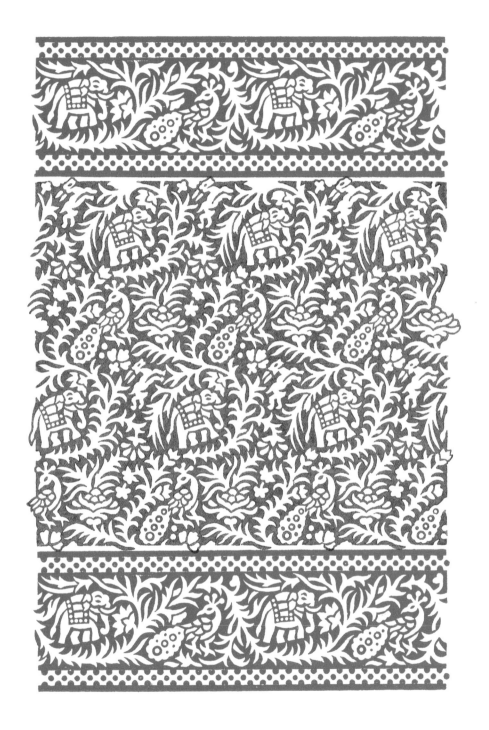

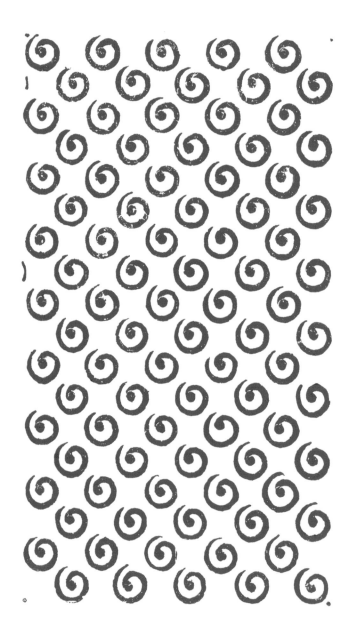

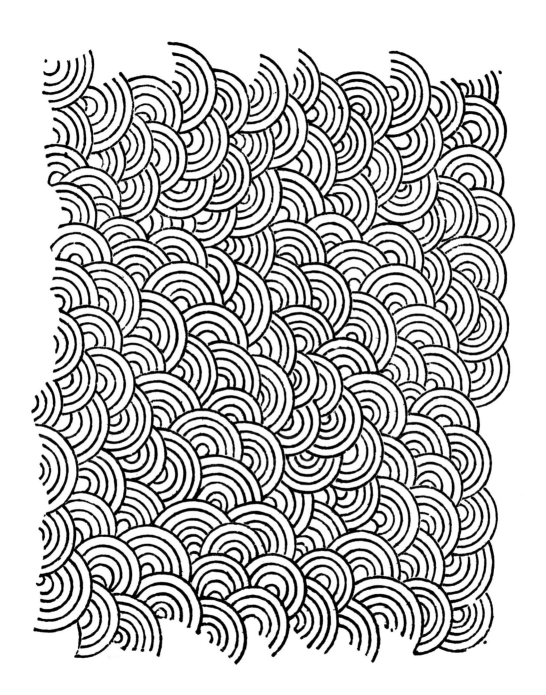

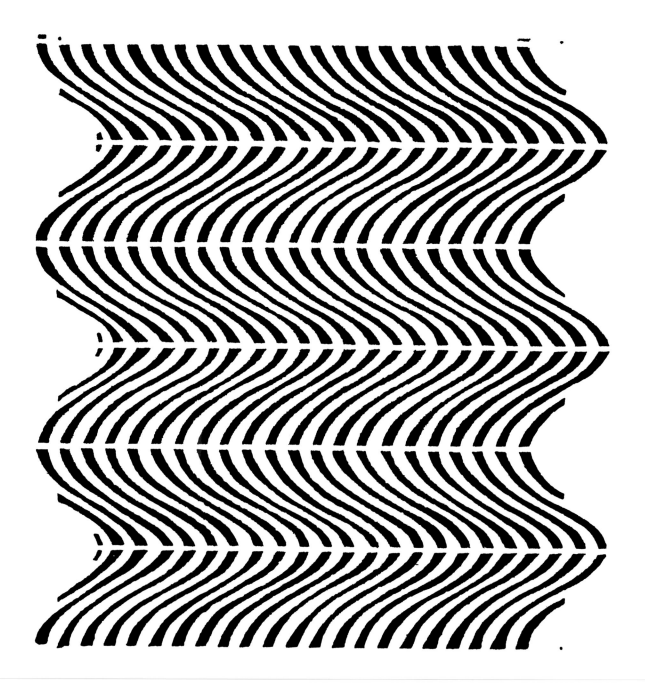

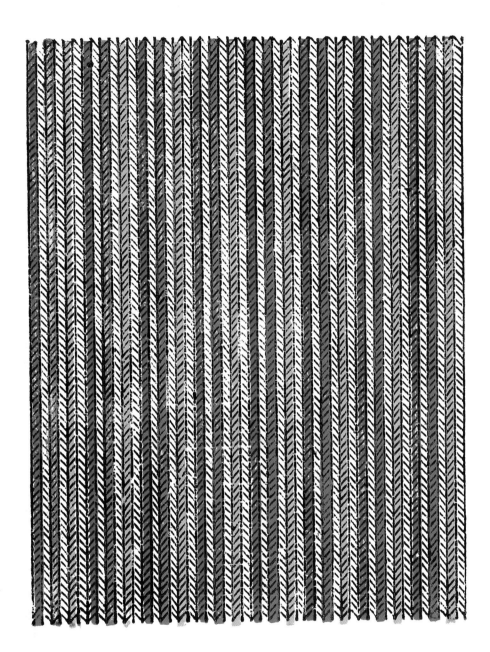

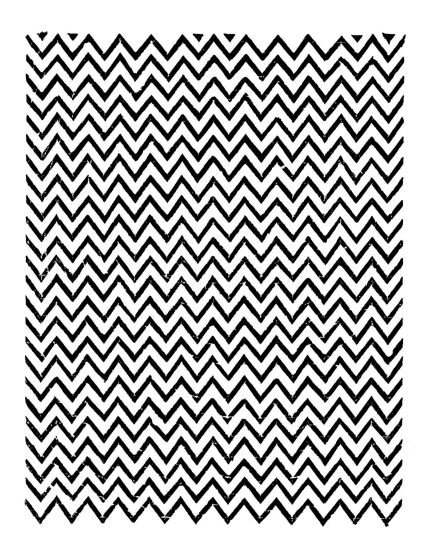

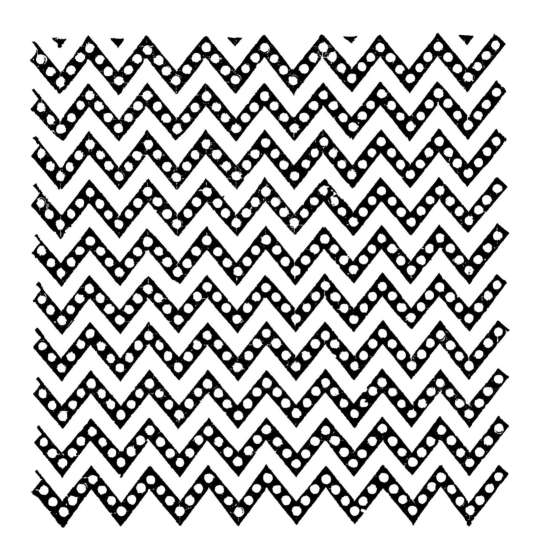

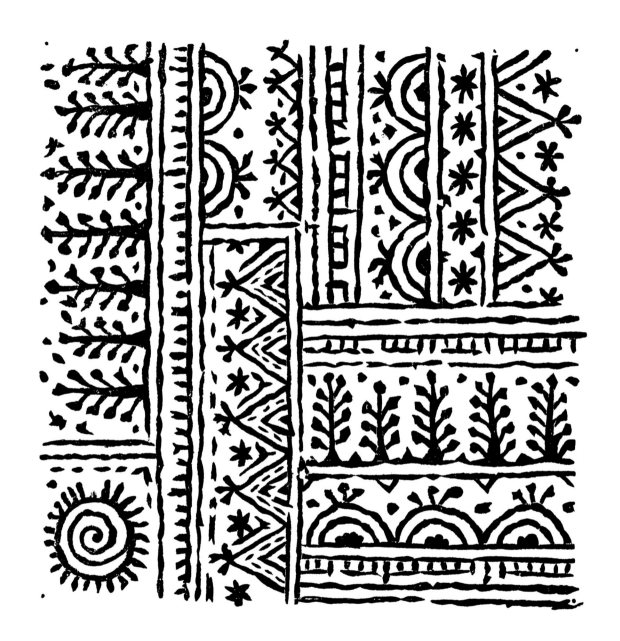

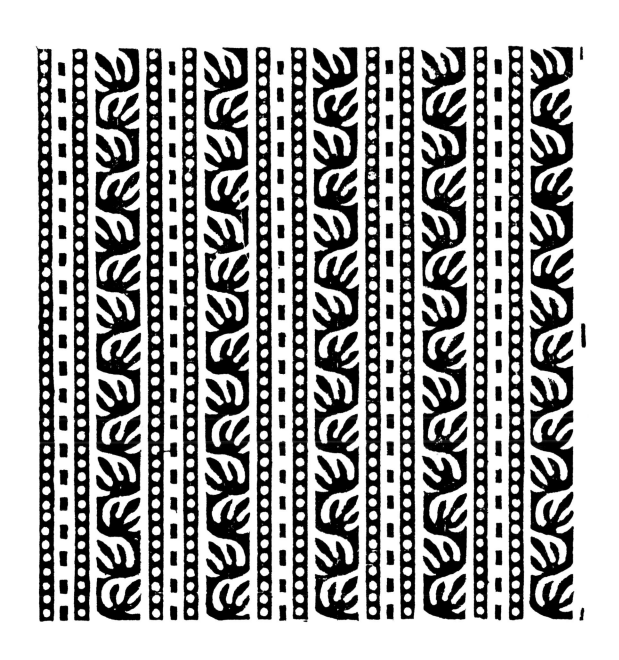

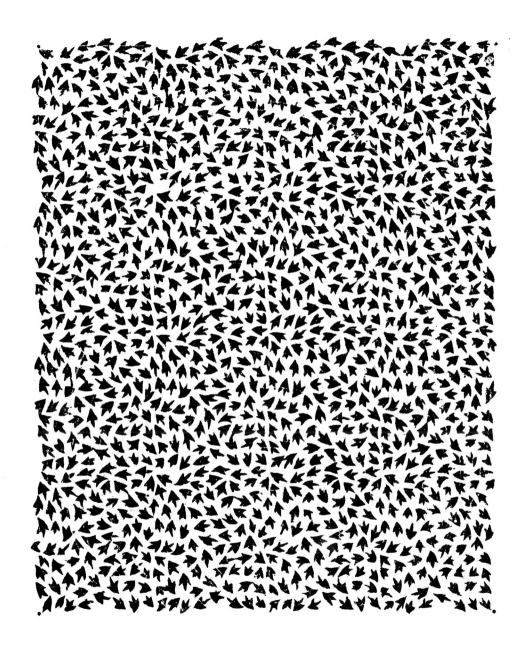

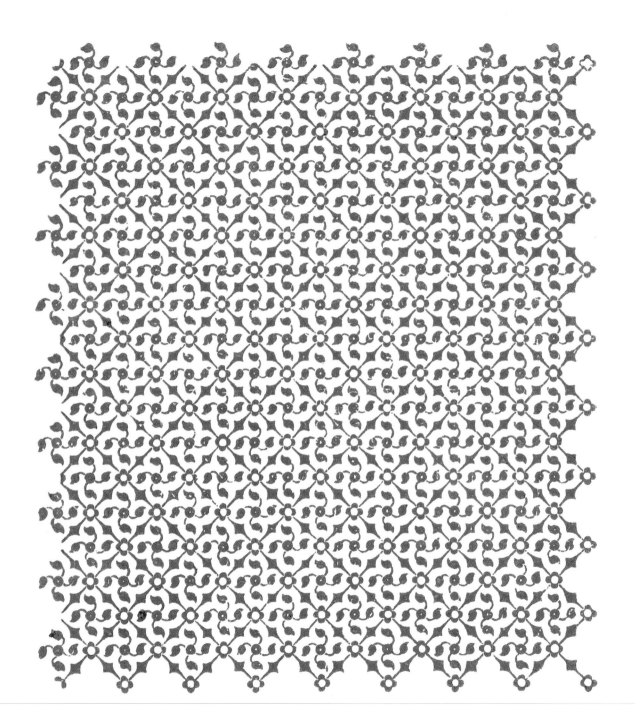

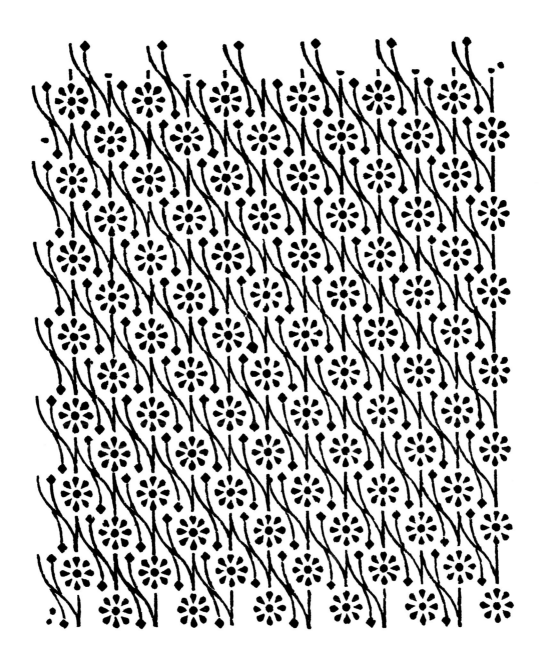

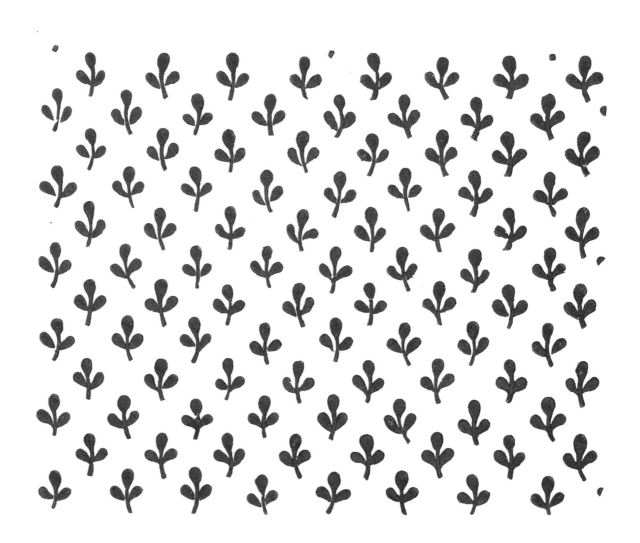

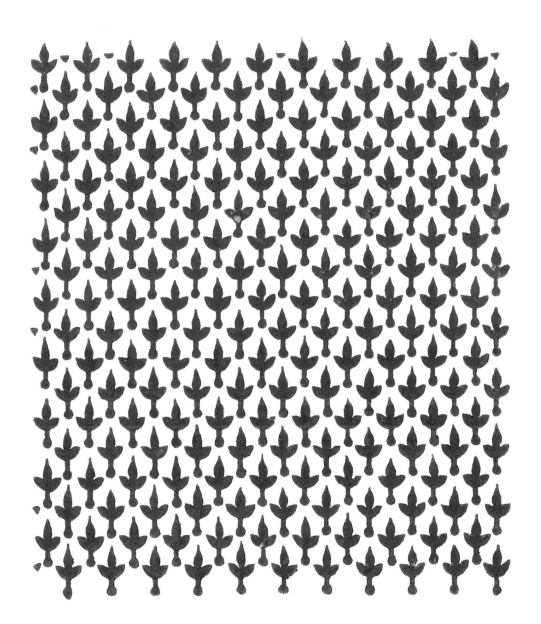

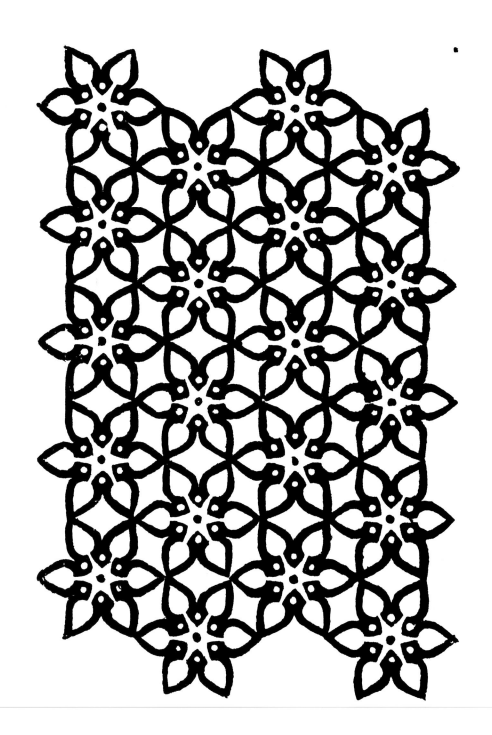

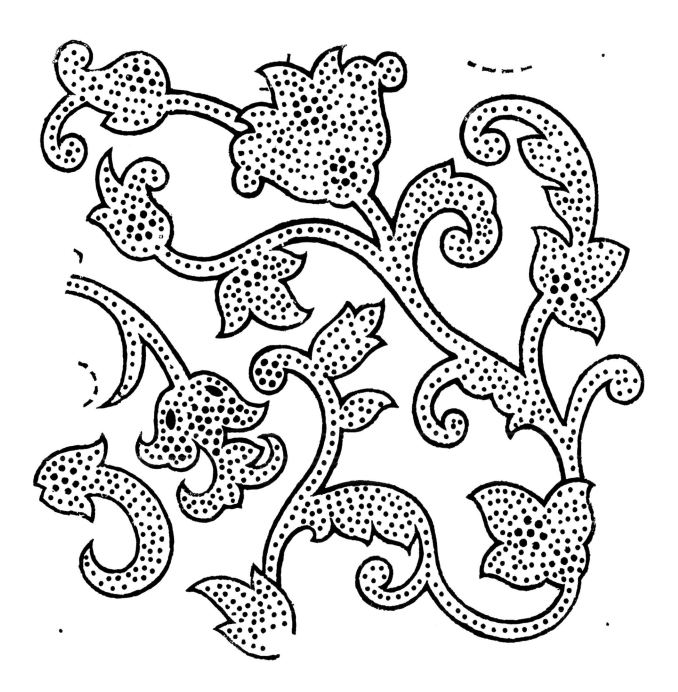

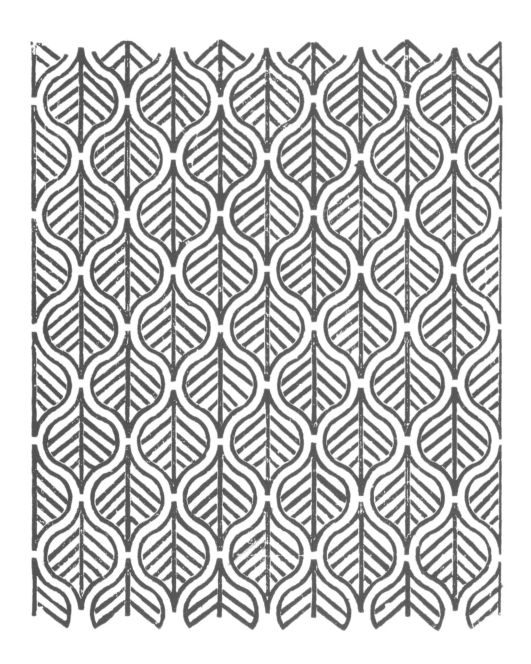

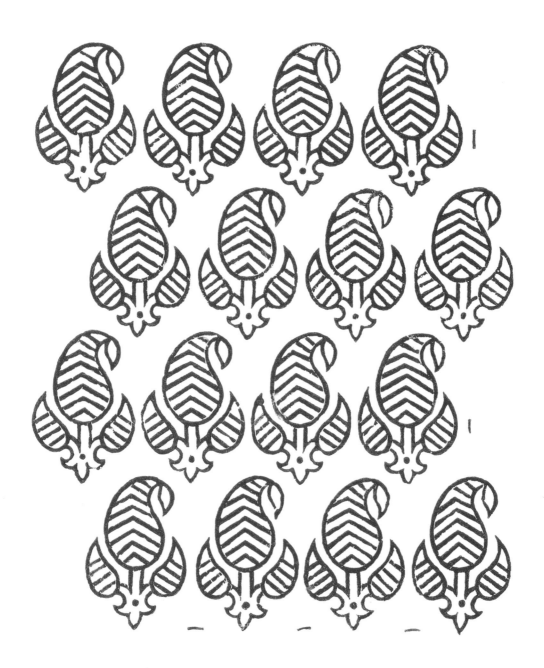

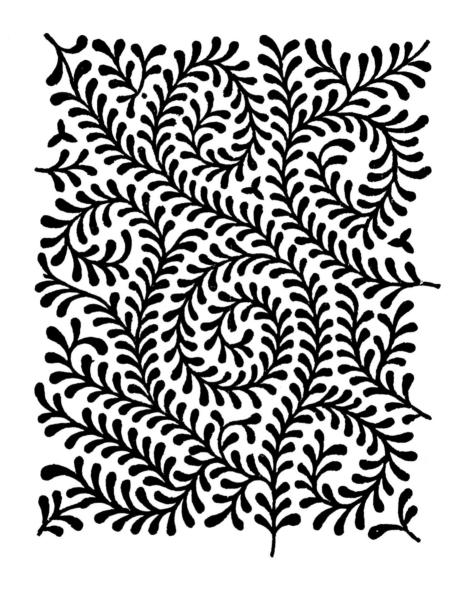

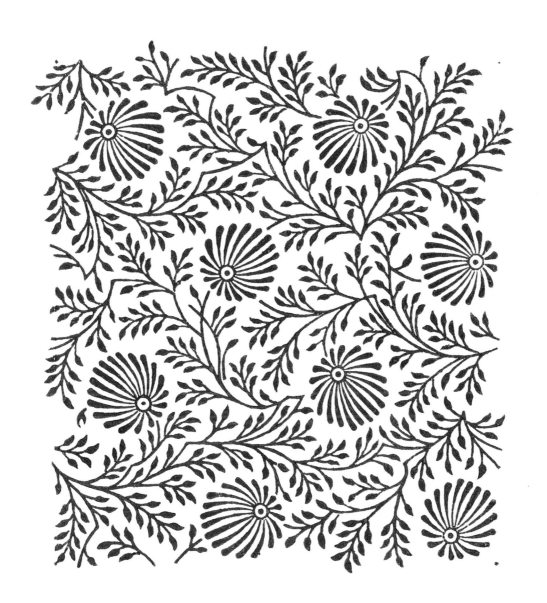

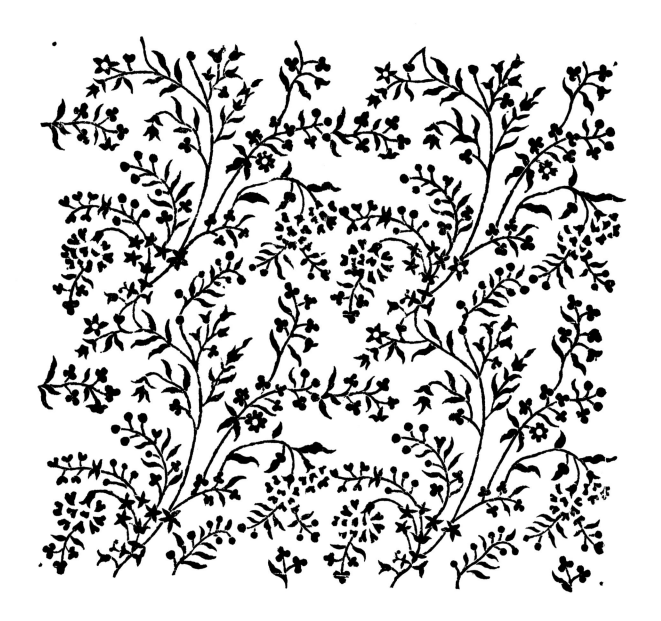

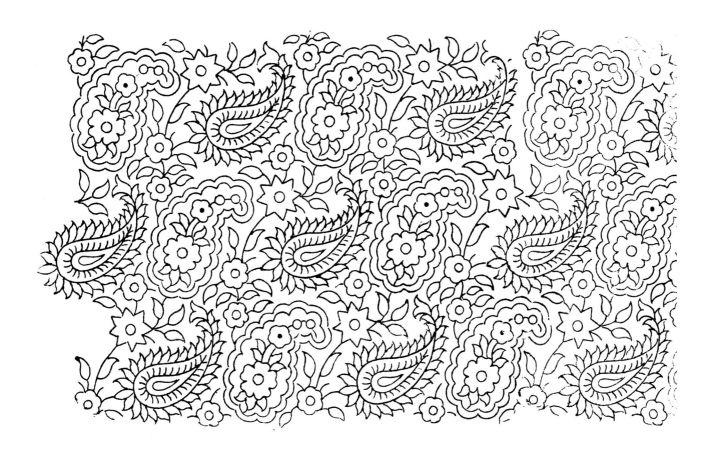

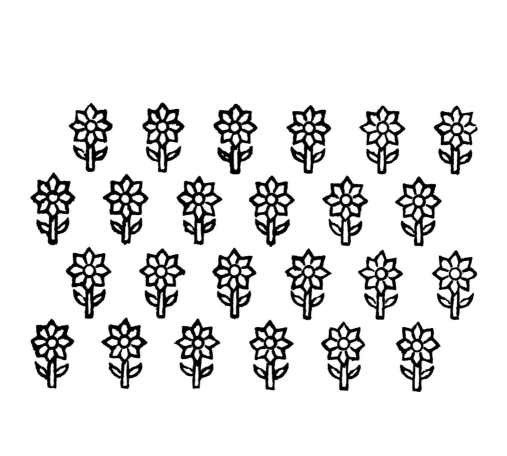

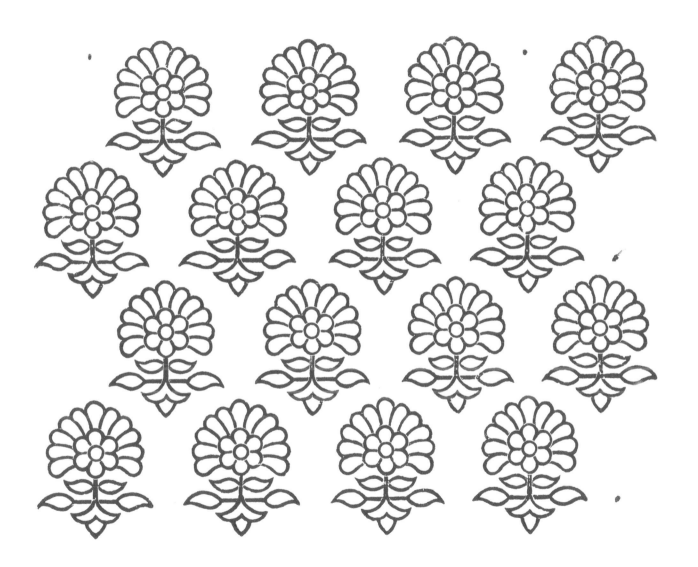

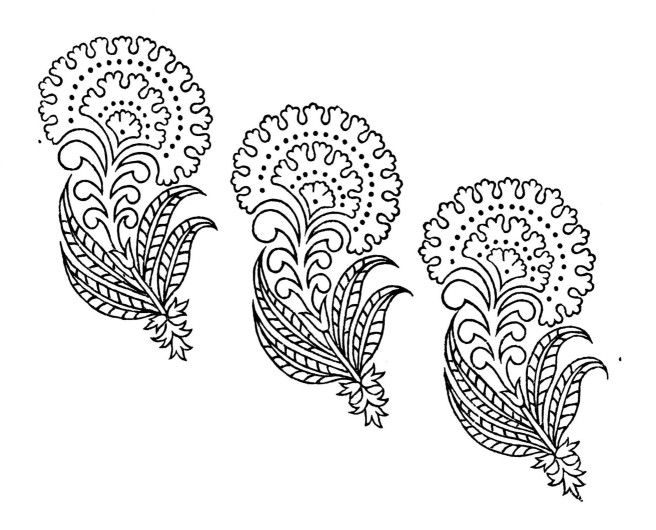

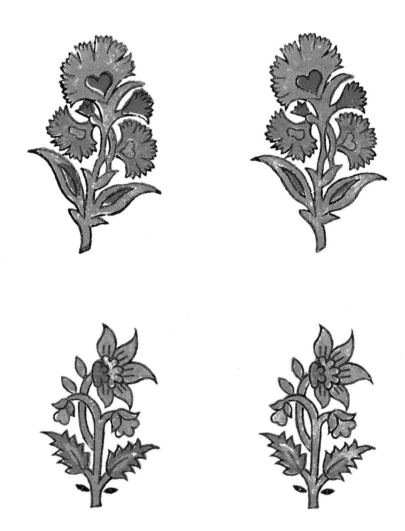

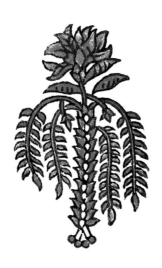

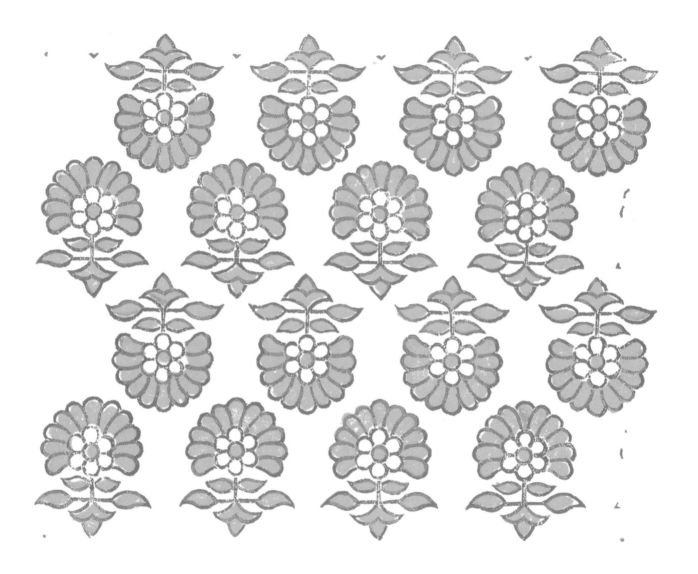

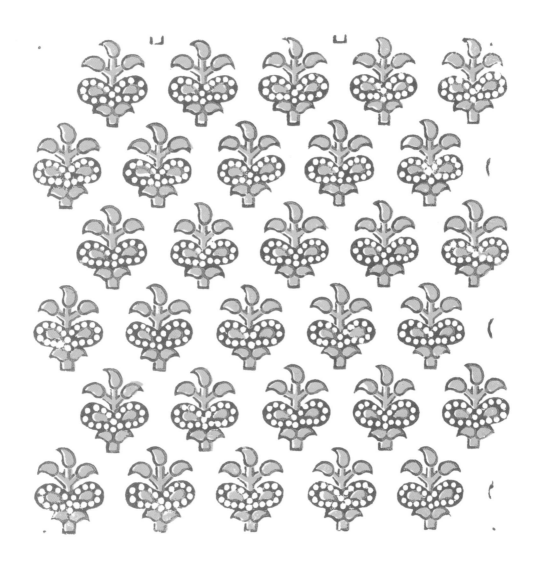

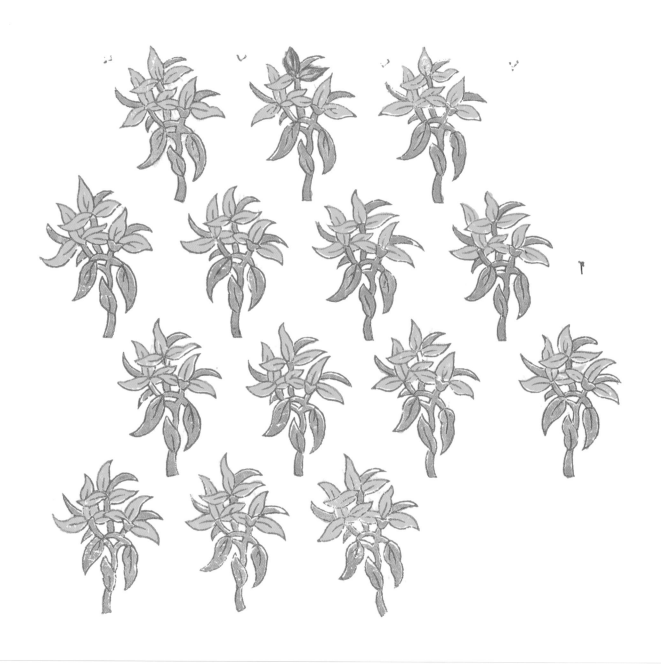

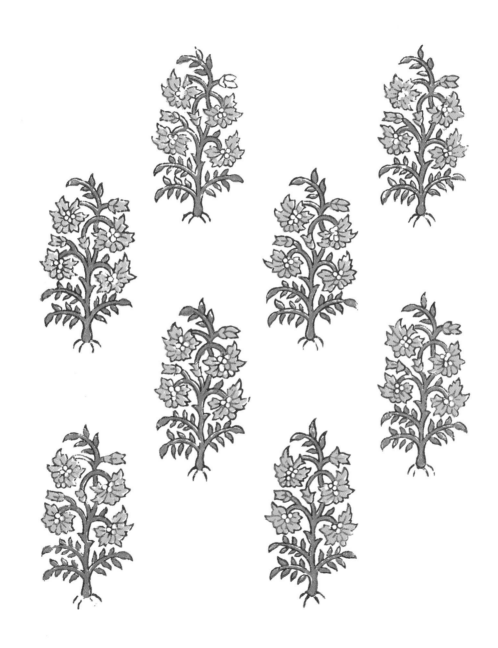

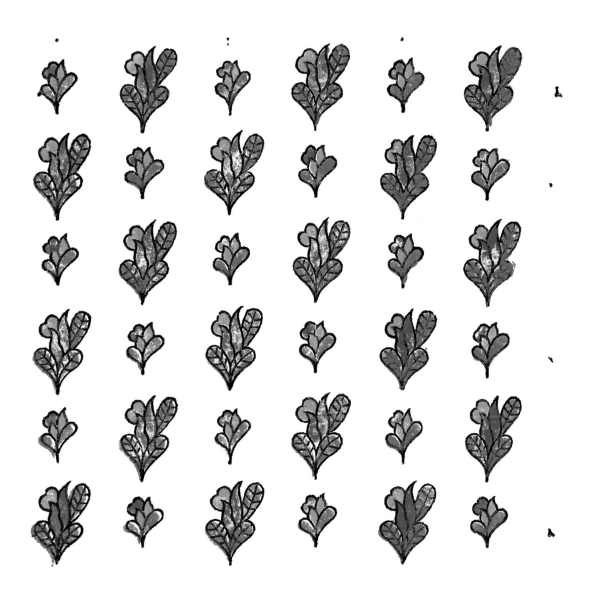

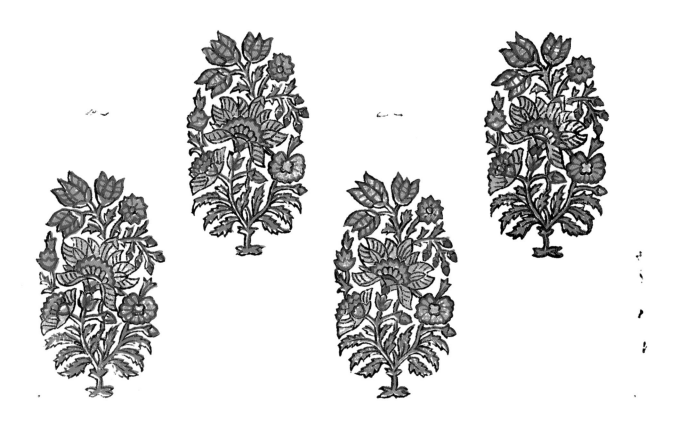

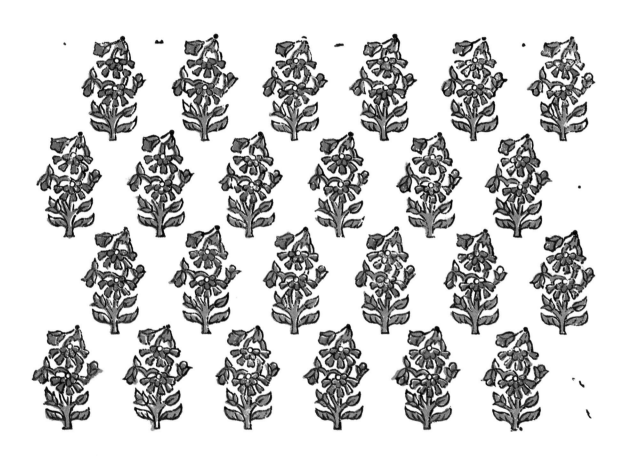

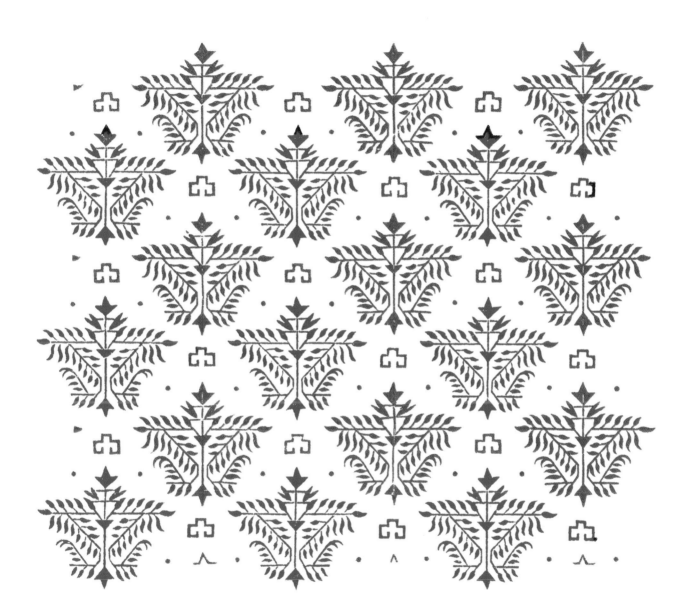

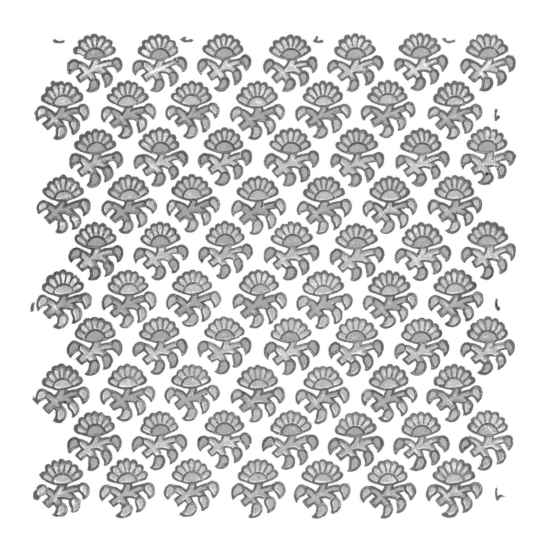

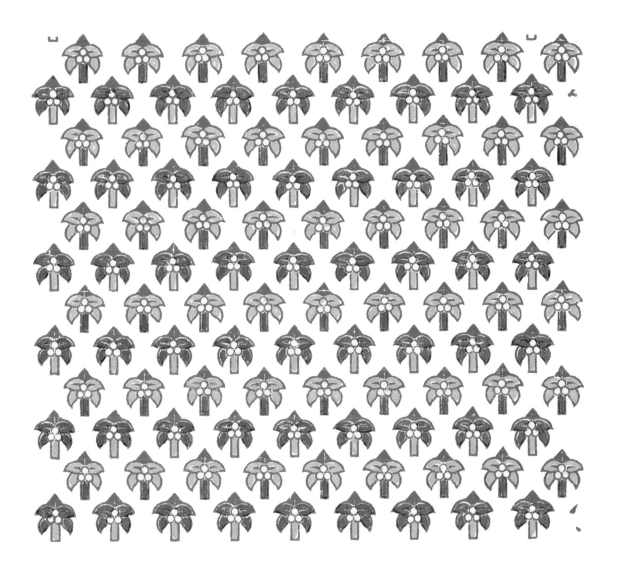

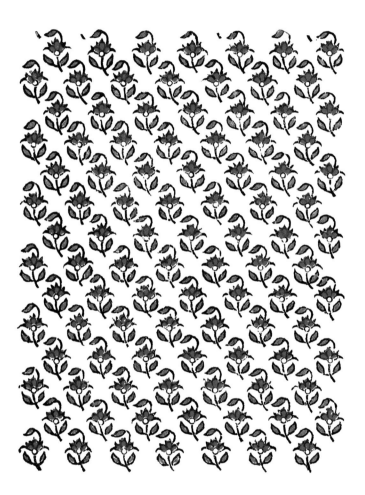

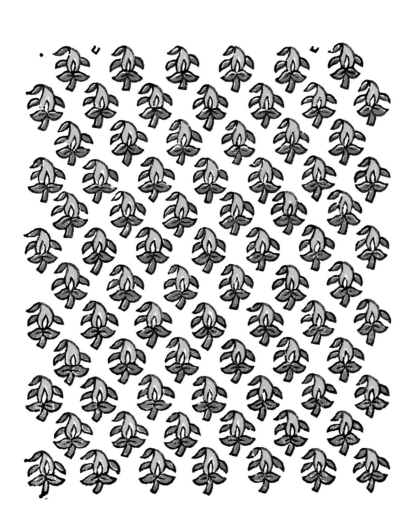

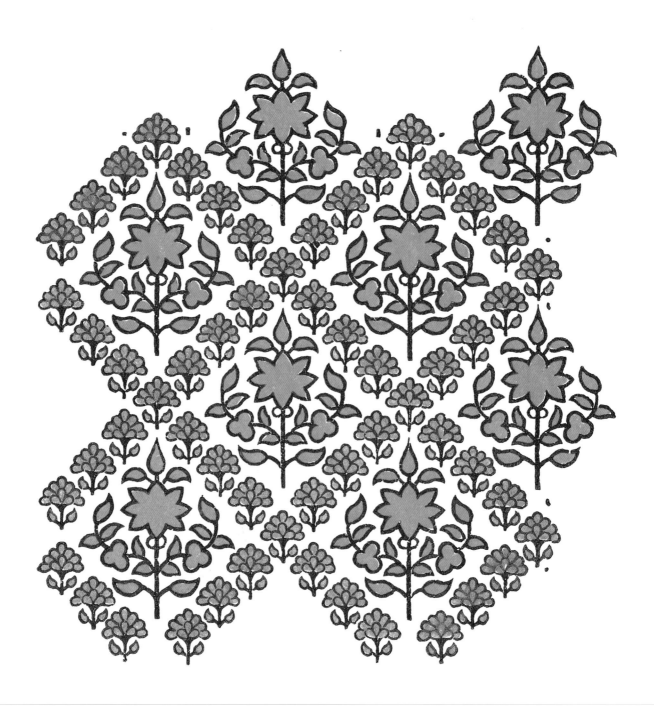

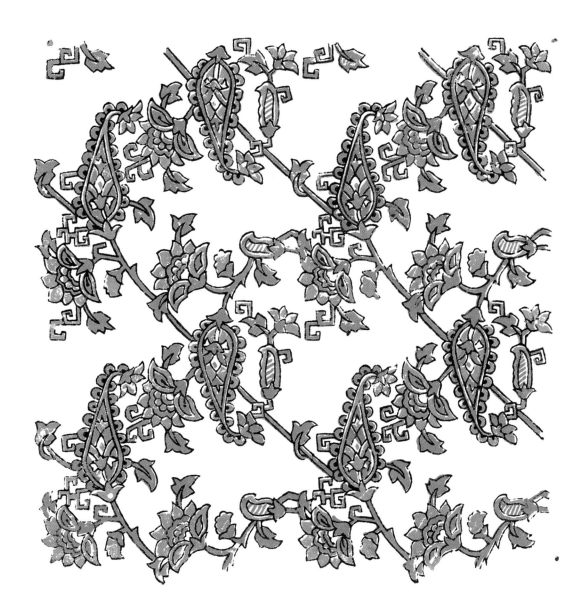

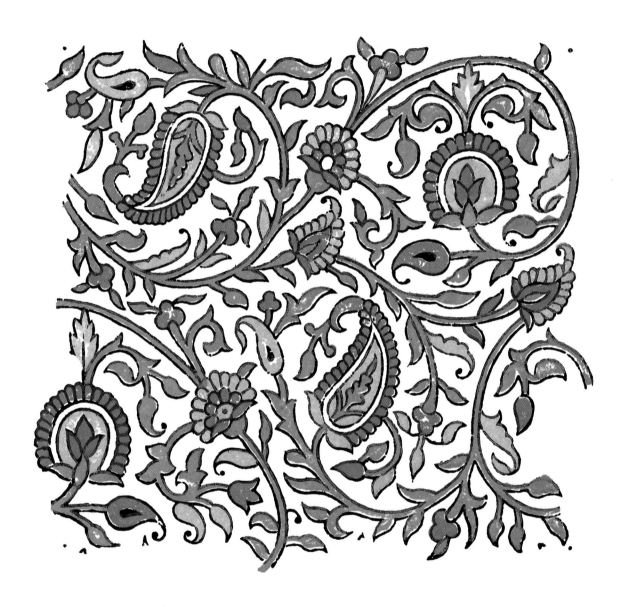

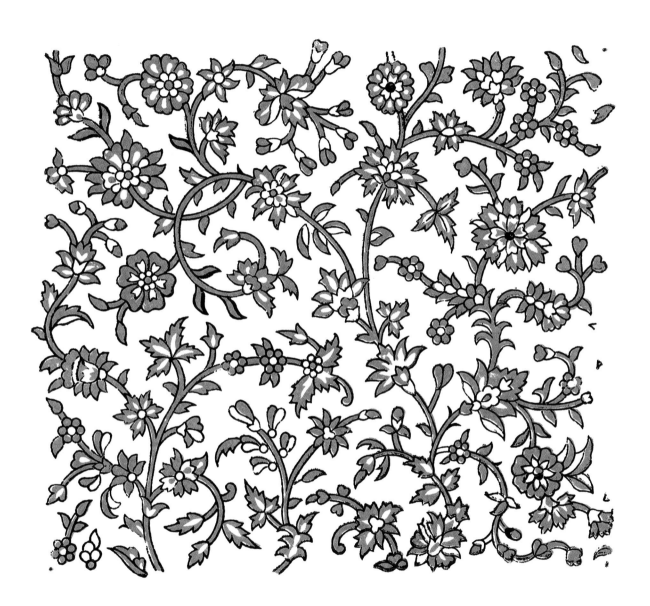

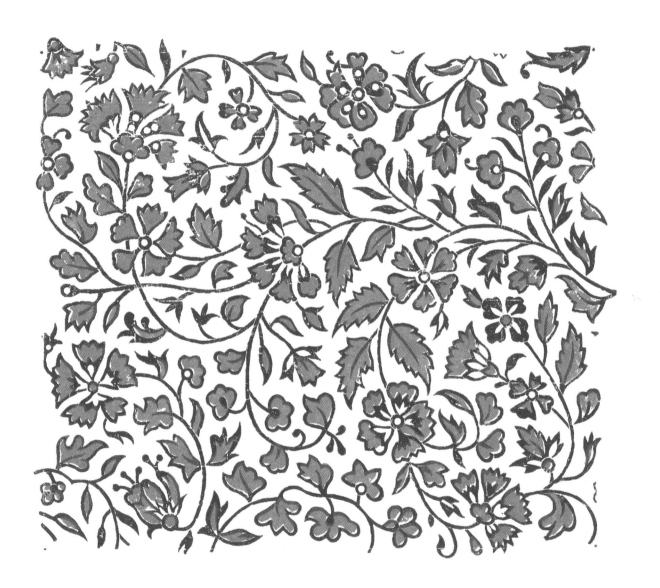

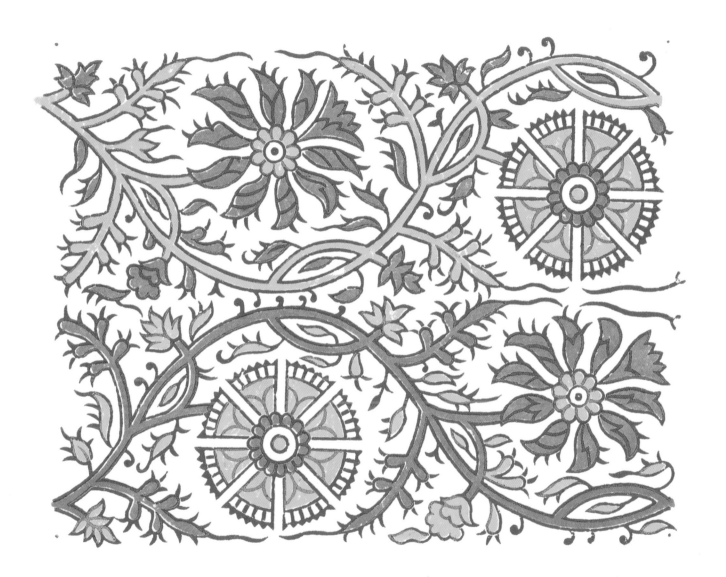

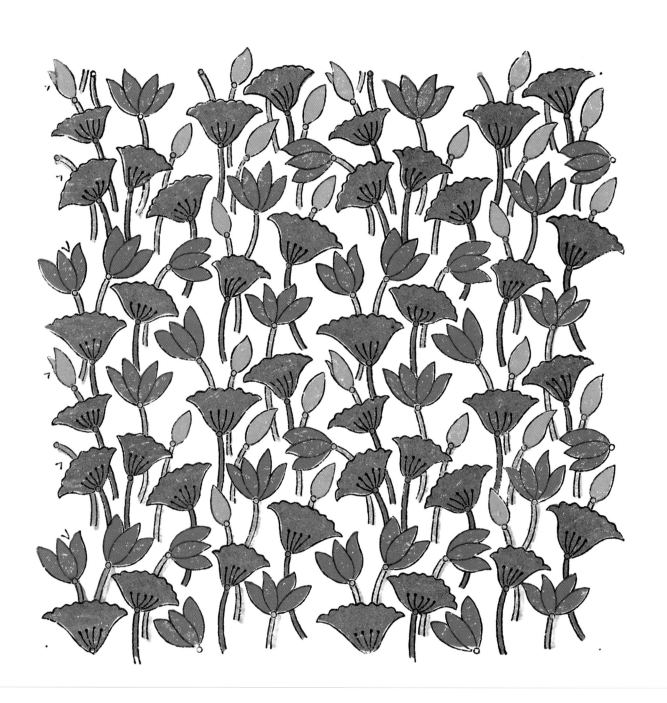

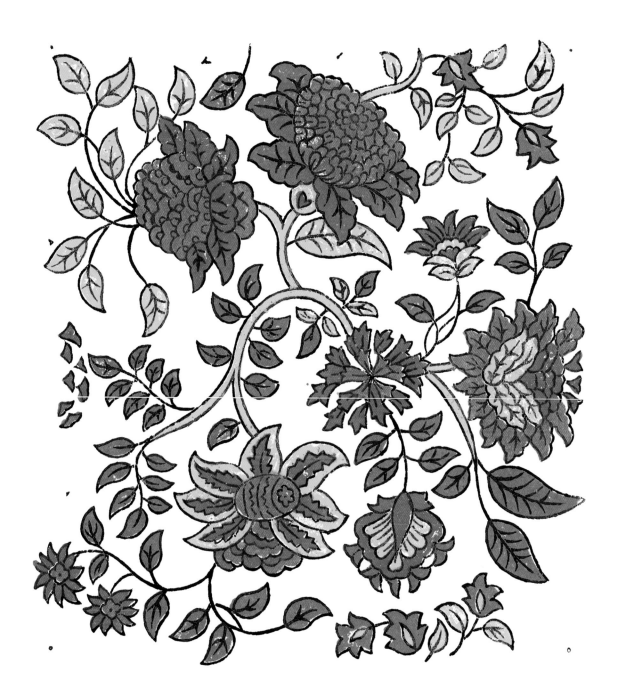

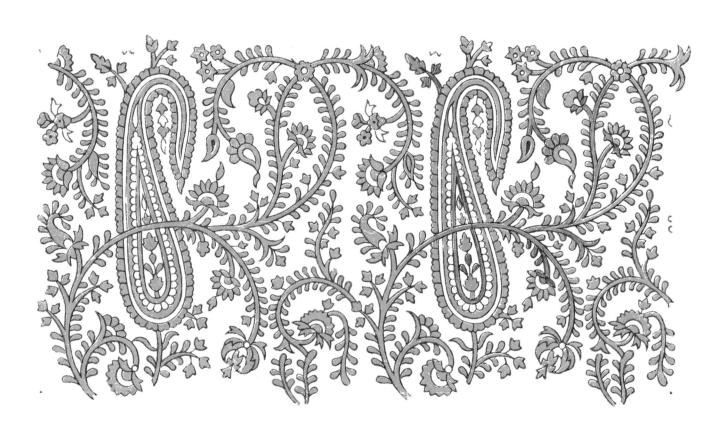

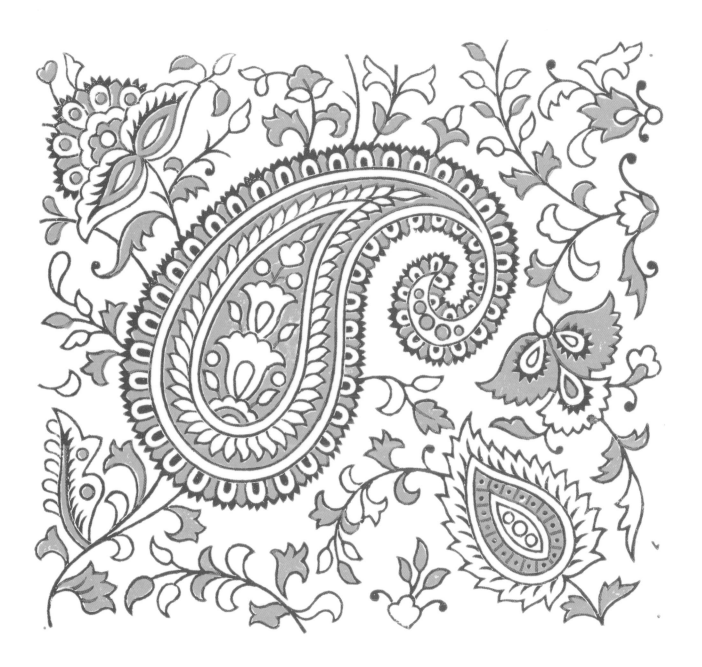

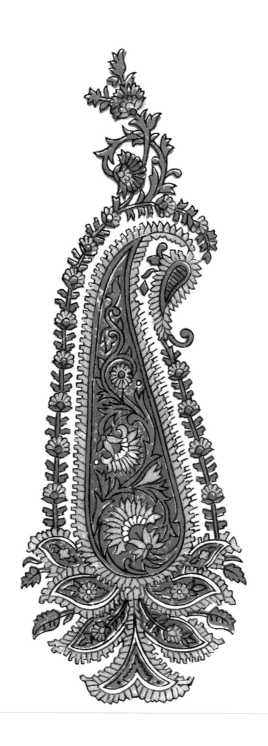

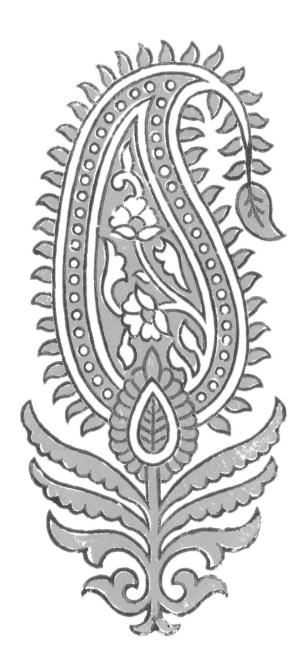

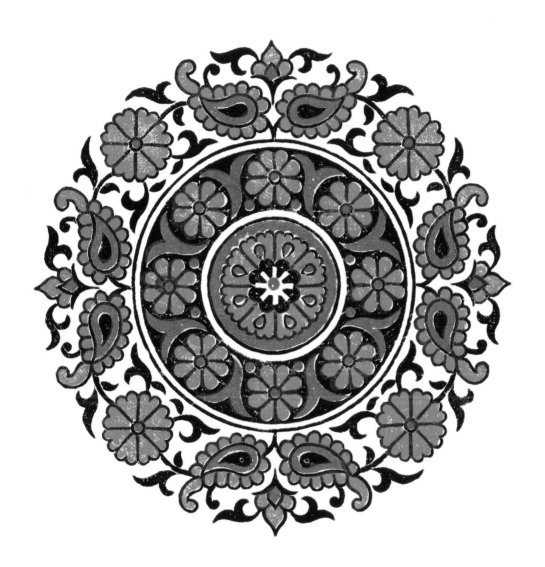

113

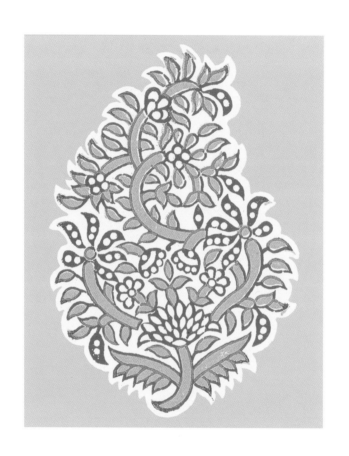

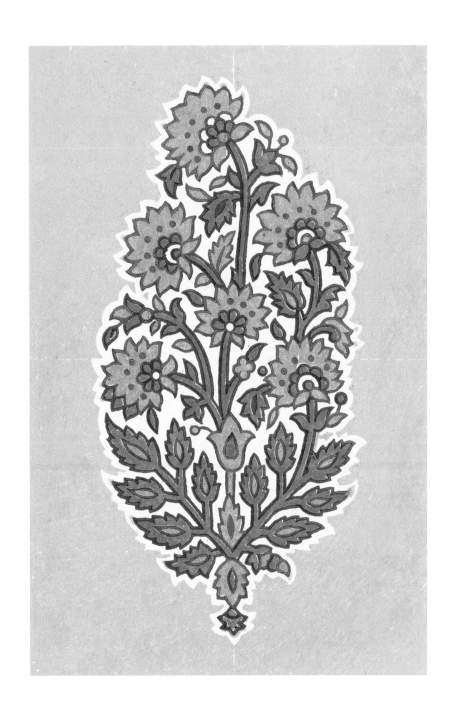

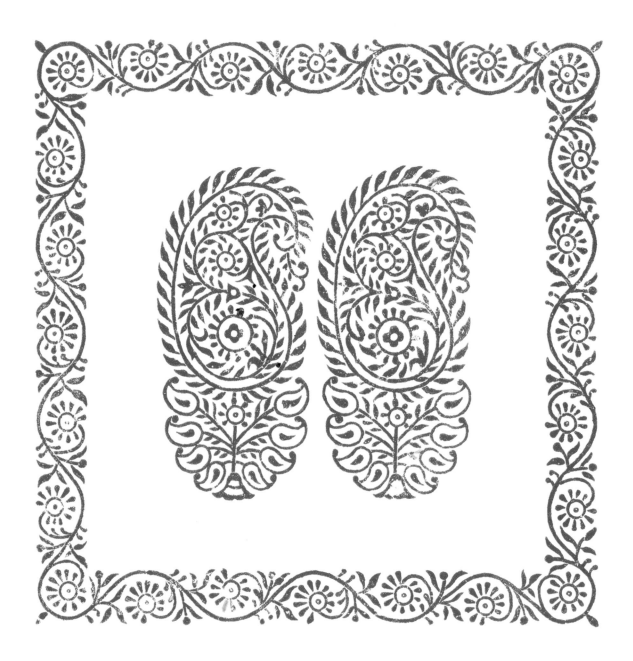

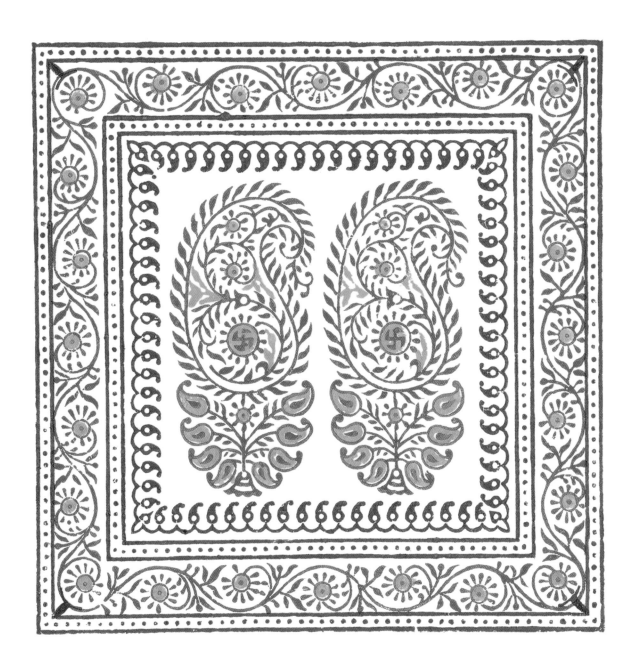

117

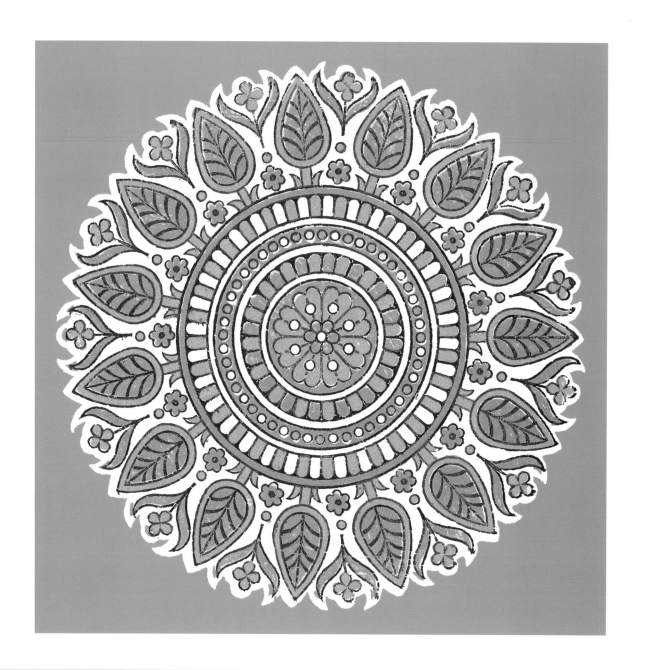

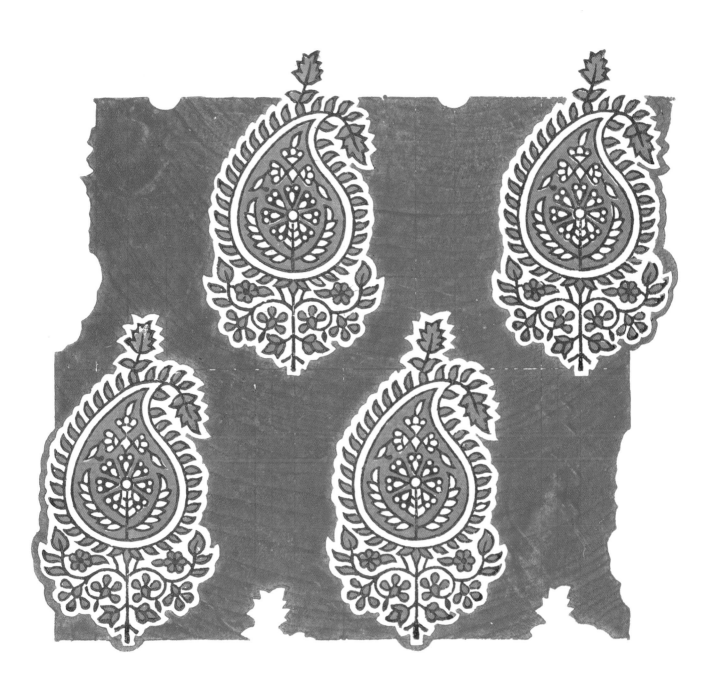

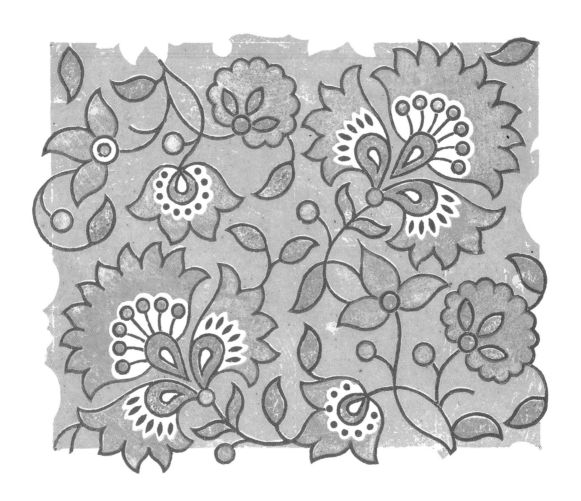

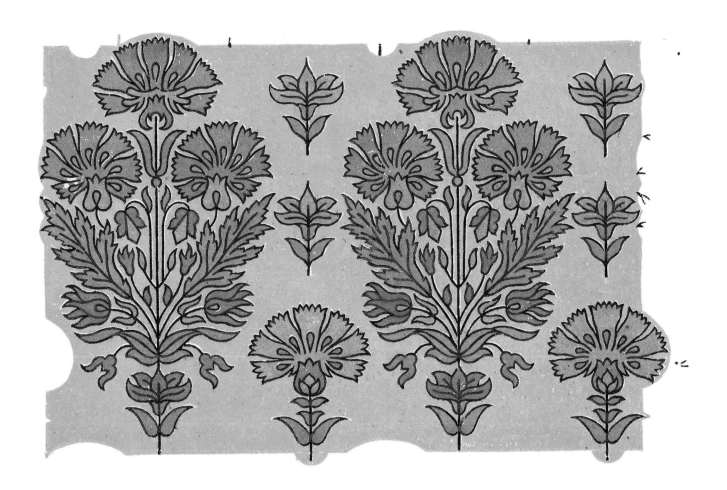

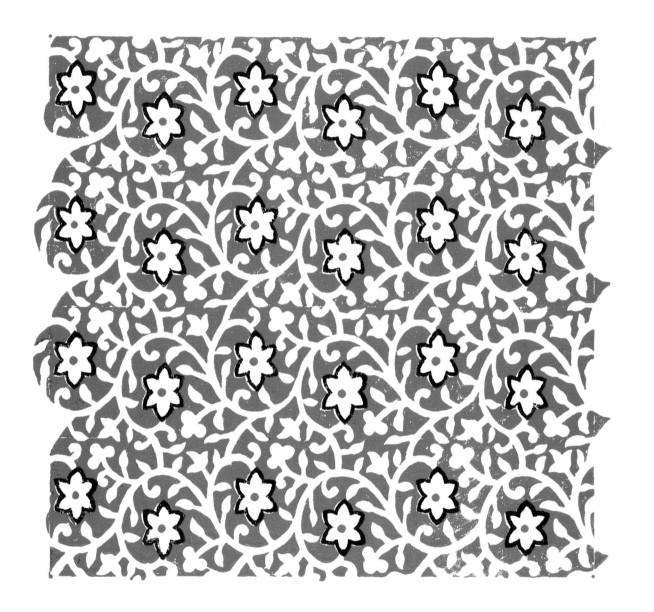

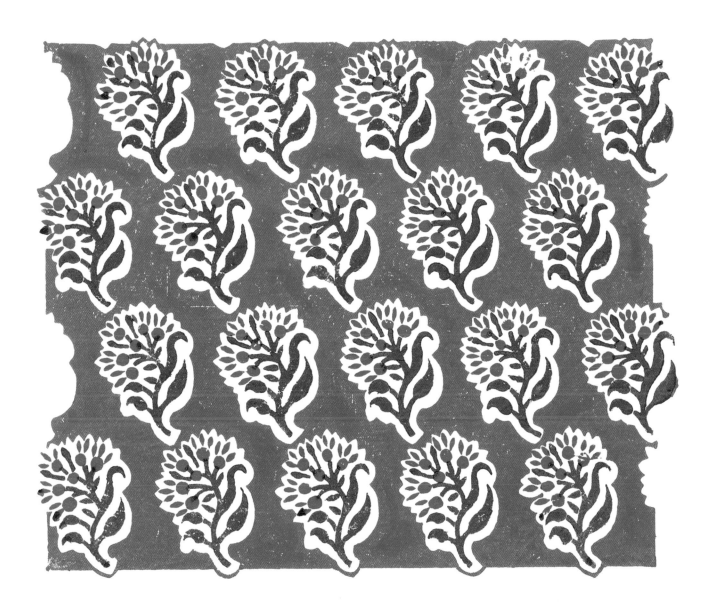

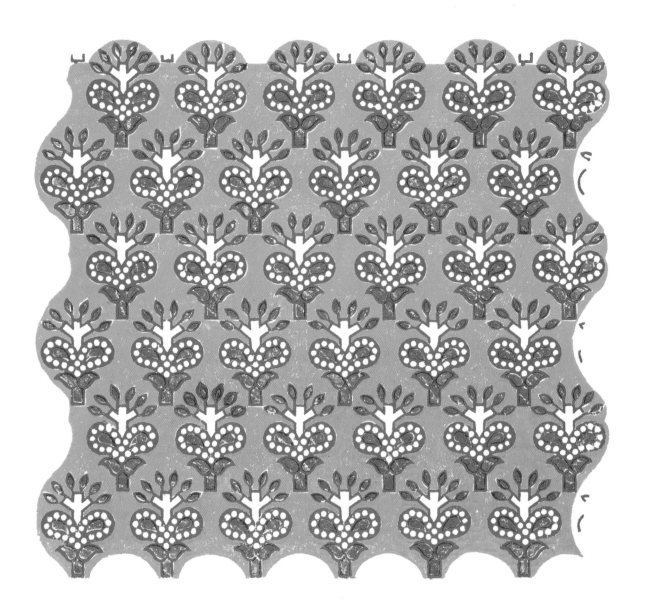

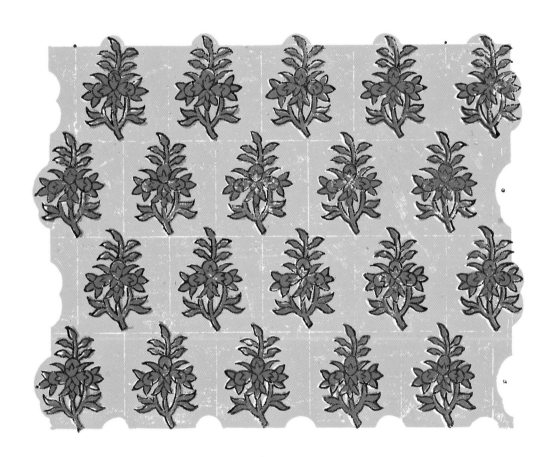

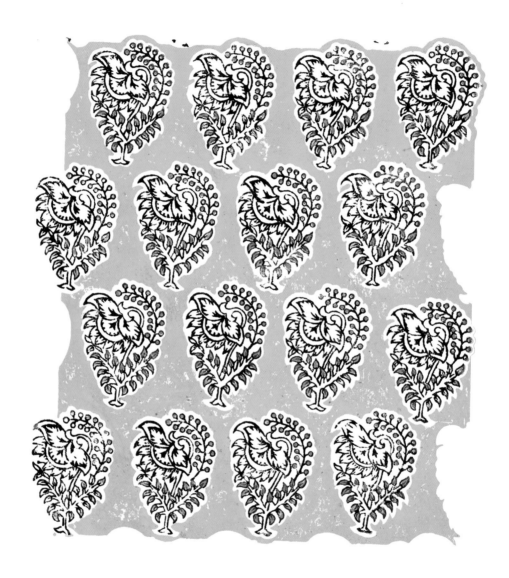

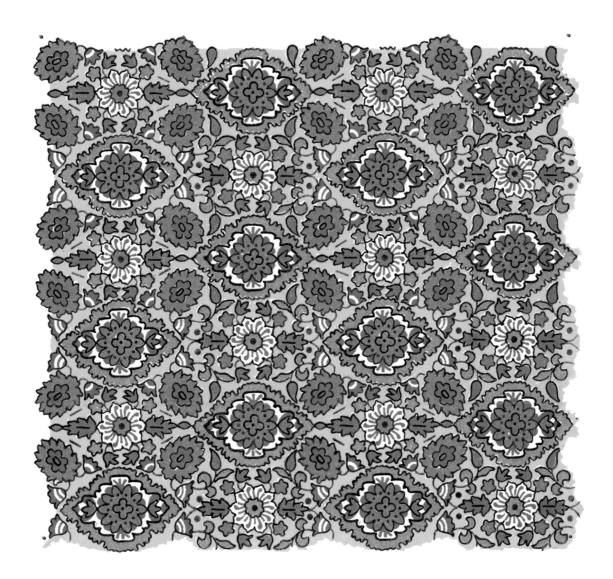

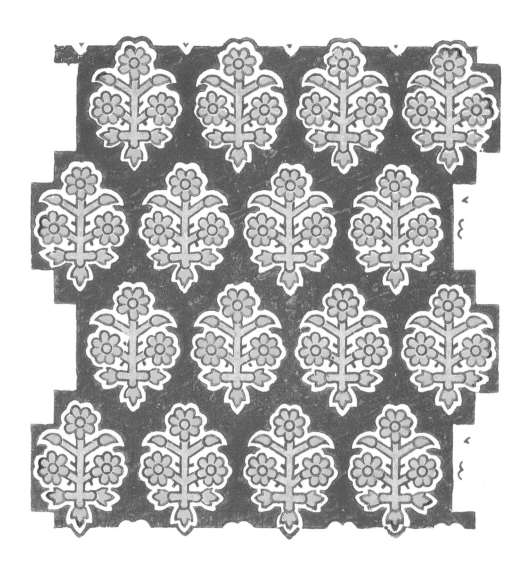

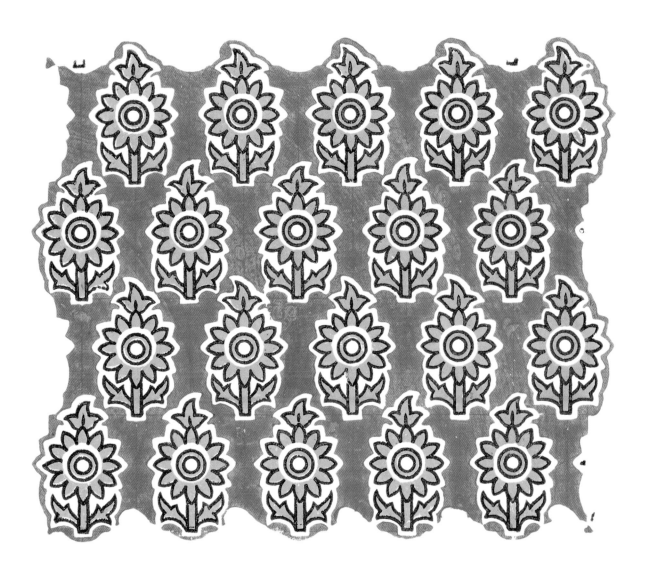

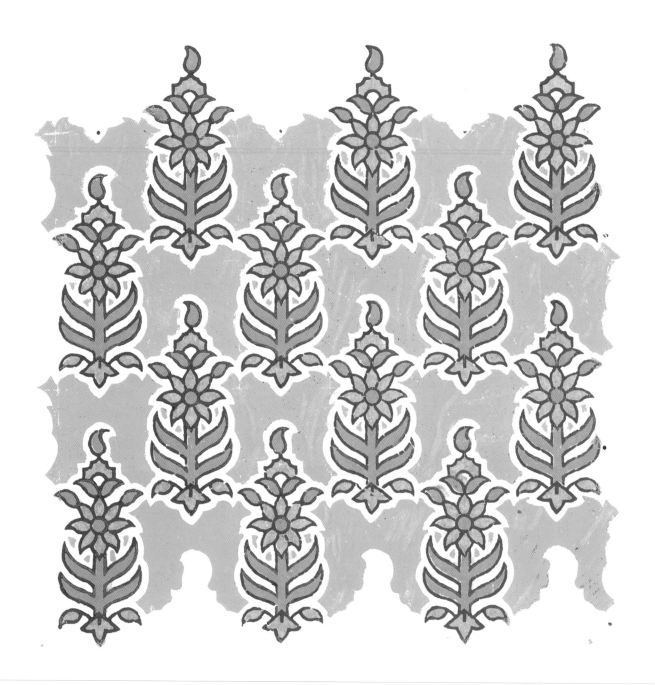

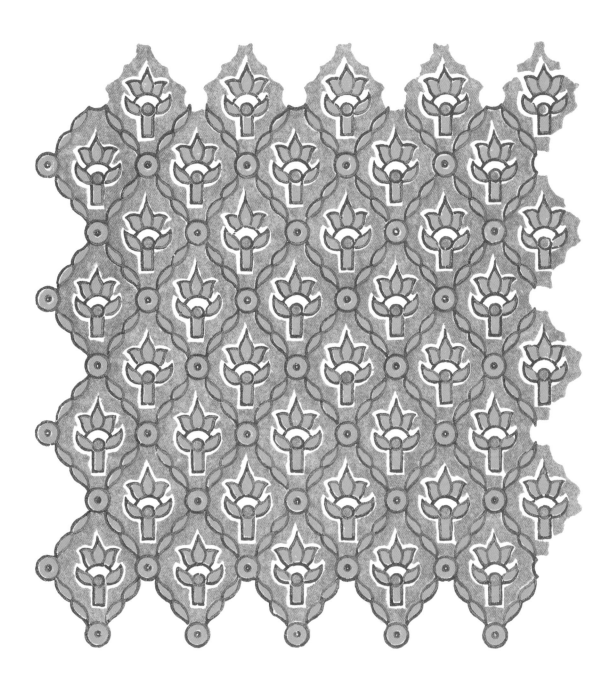

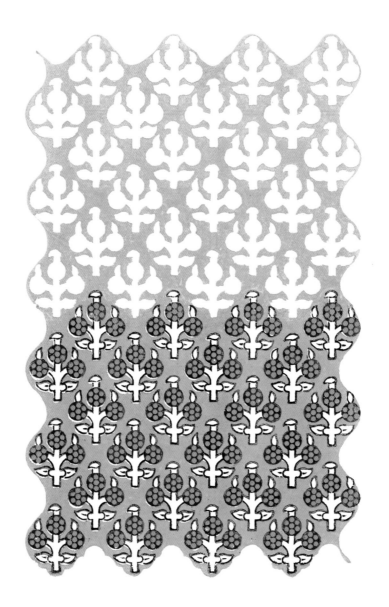

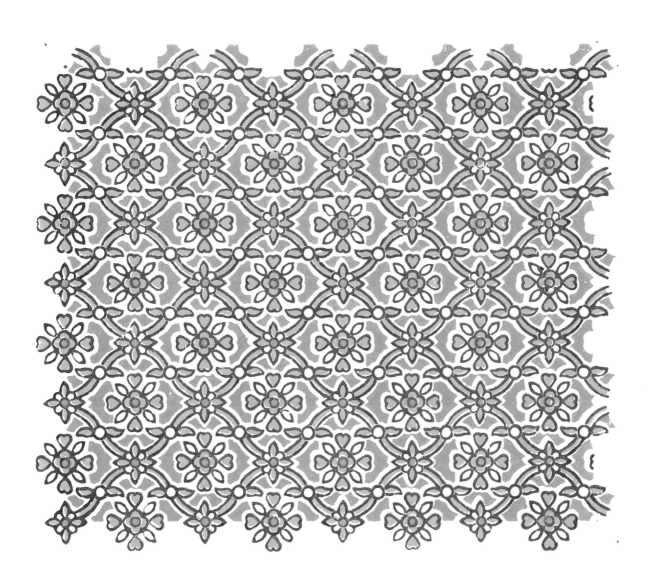

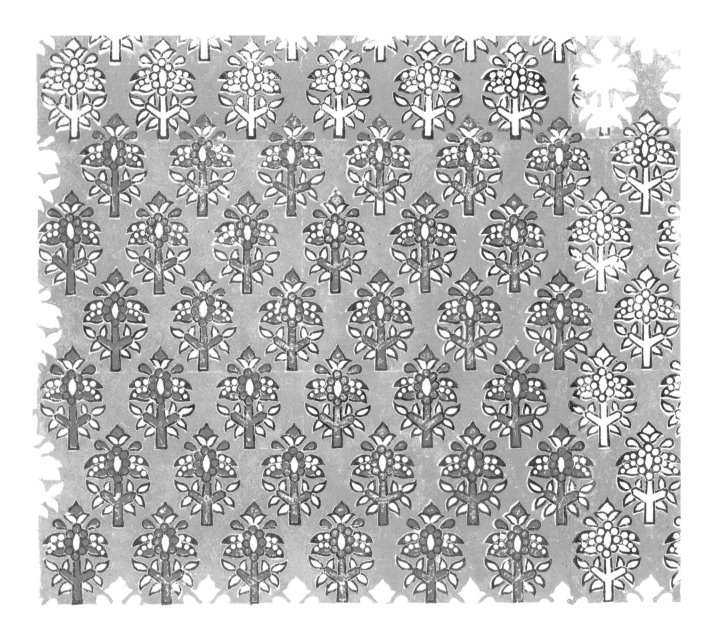

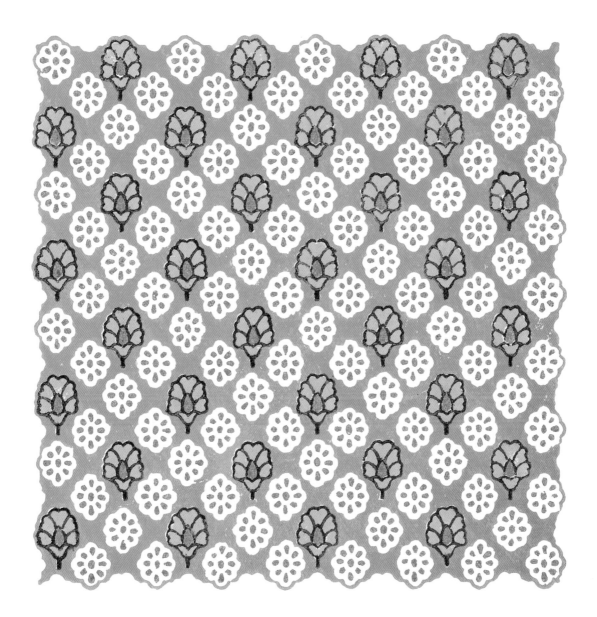

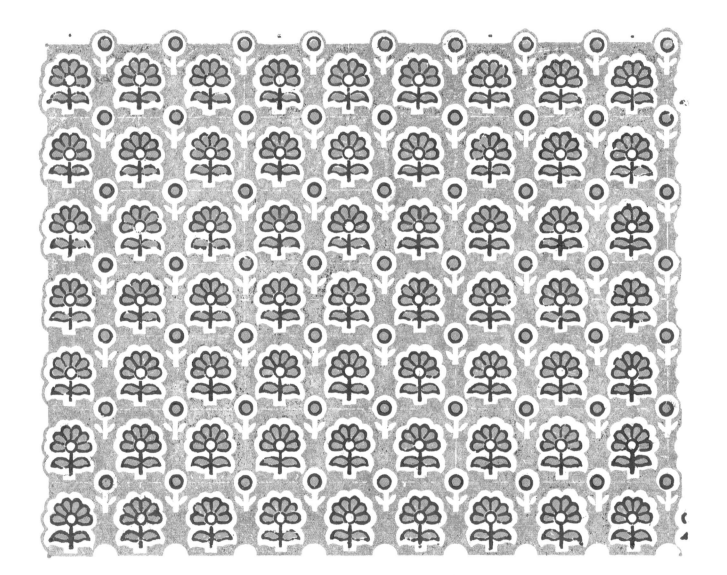

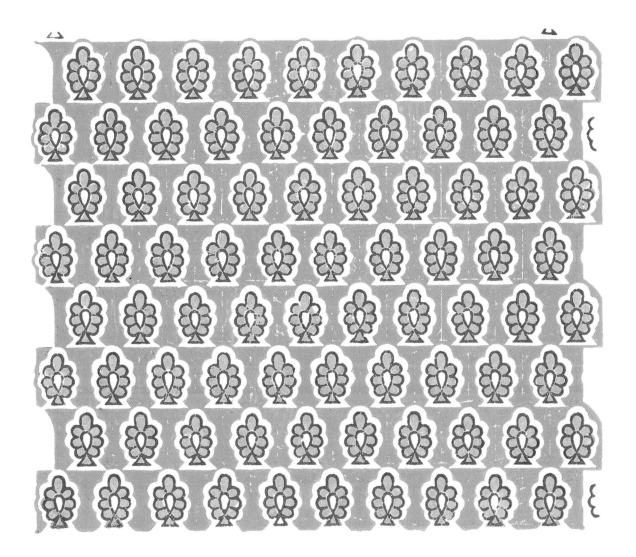

137

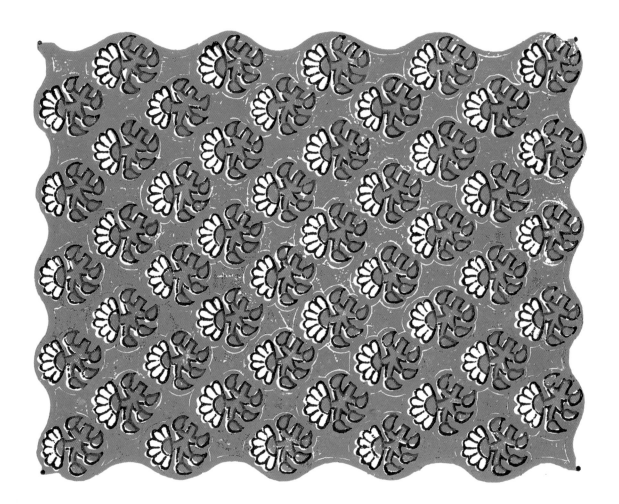

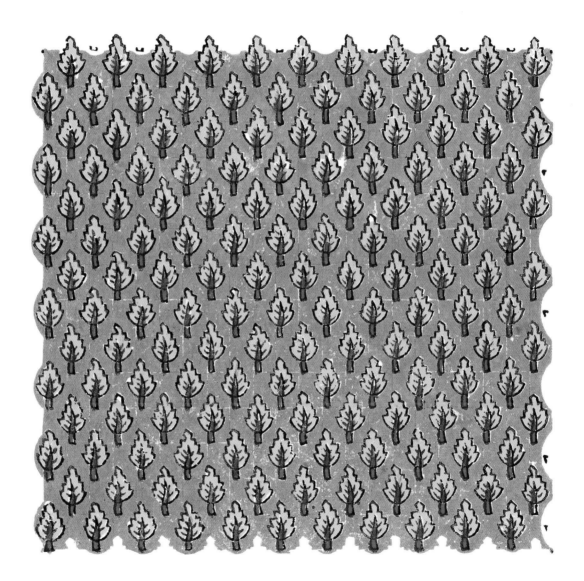